Adult Color By Number Sugar Skulls

This Sugar Skulls Coloring book belongs to:

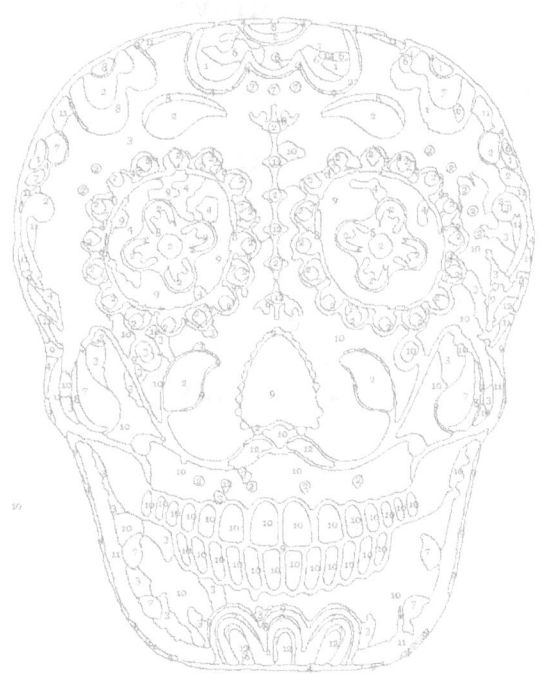

Copyright © 2019 Sugar Skulls Coloring Books

1. Red
2. Green
3. Blue
4. Pink
5. Purple
6. Light Blue
7. Light Green
8. Orange
9. Dark Red
10. Brown
11. Black
12. Dark Green
13. Gold
14. Violet
15. Yellow

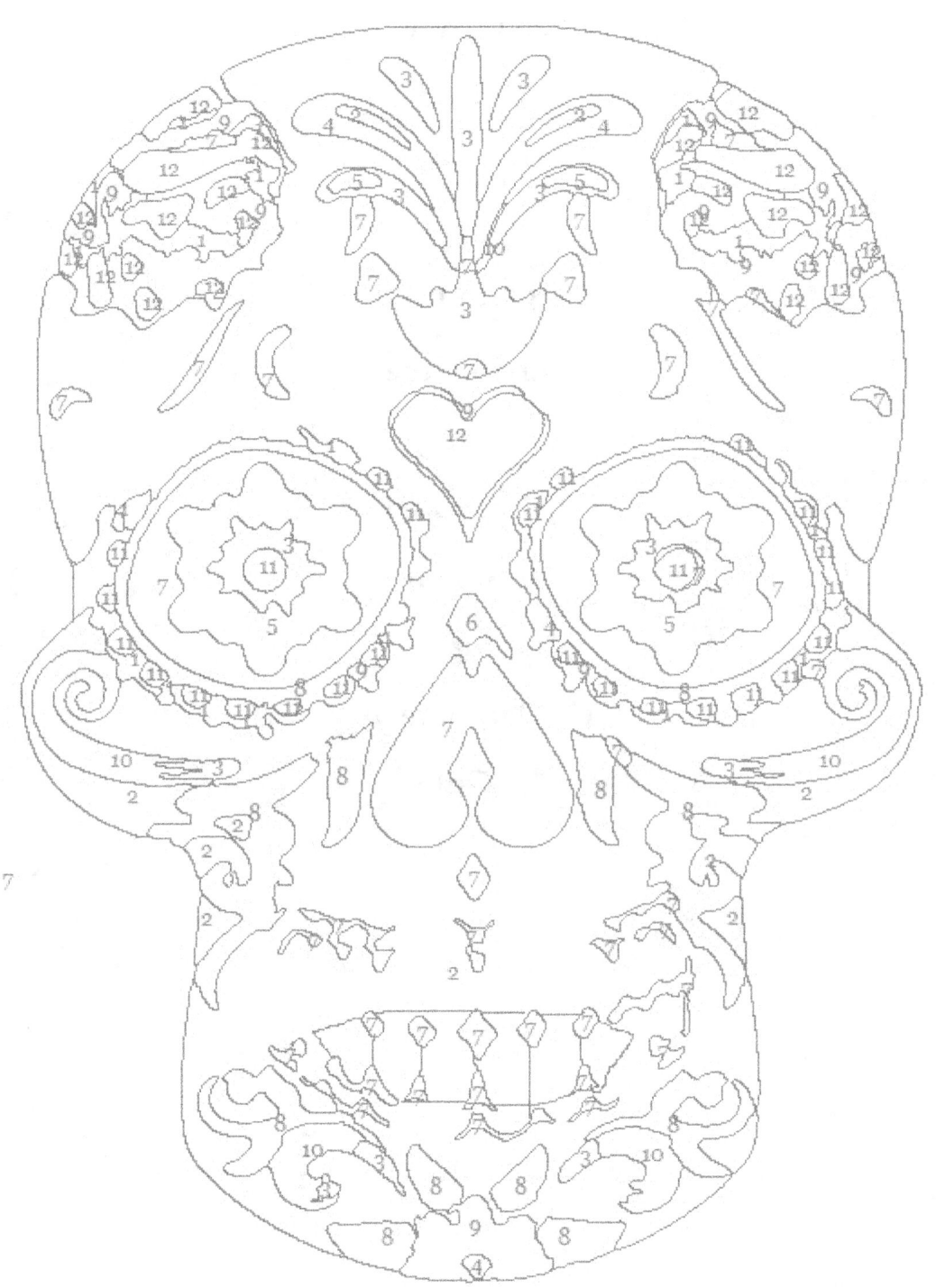

1. Red
2. Green
3. Blue
4. Pink
5. Purple
6. Light Blue
7. Light Green
8. Orange
9. Dark Red
10. Brown
11. Black
12. Dark Green
13. Gold
14. Violet
15. Yellow

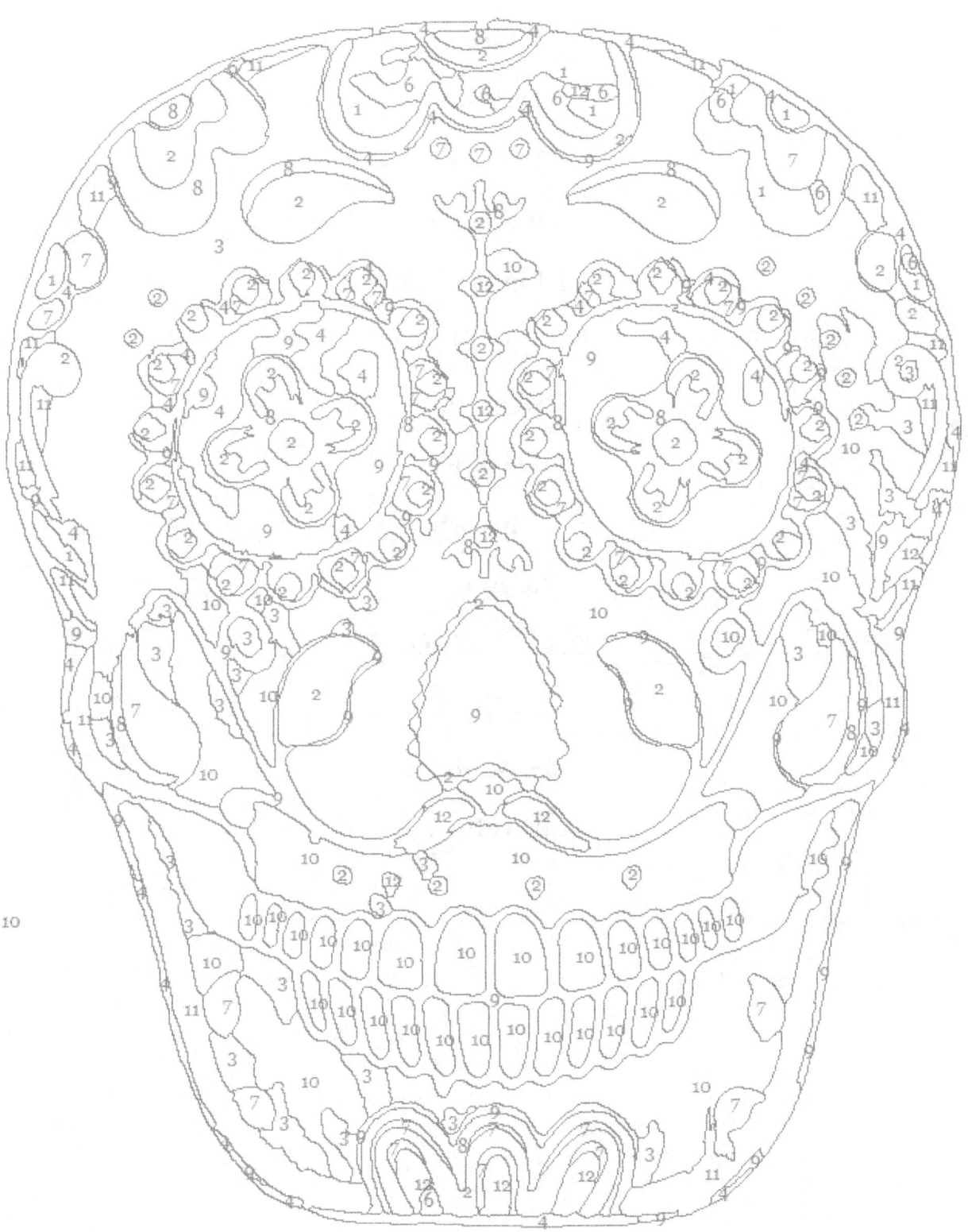

16. Red
17. Green
18. Blue
19. Pink
20. Purple
21. Light Blue
22. Light Green
23. Orange
24. Dark Red
25. Brown
26. Black
27. Dark Green
28. Gold
29. Violet
30. Yellow

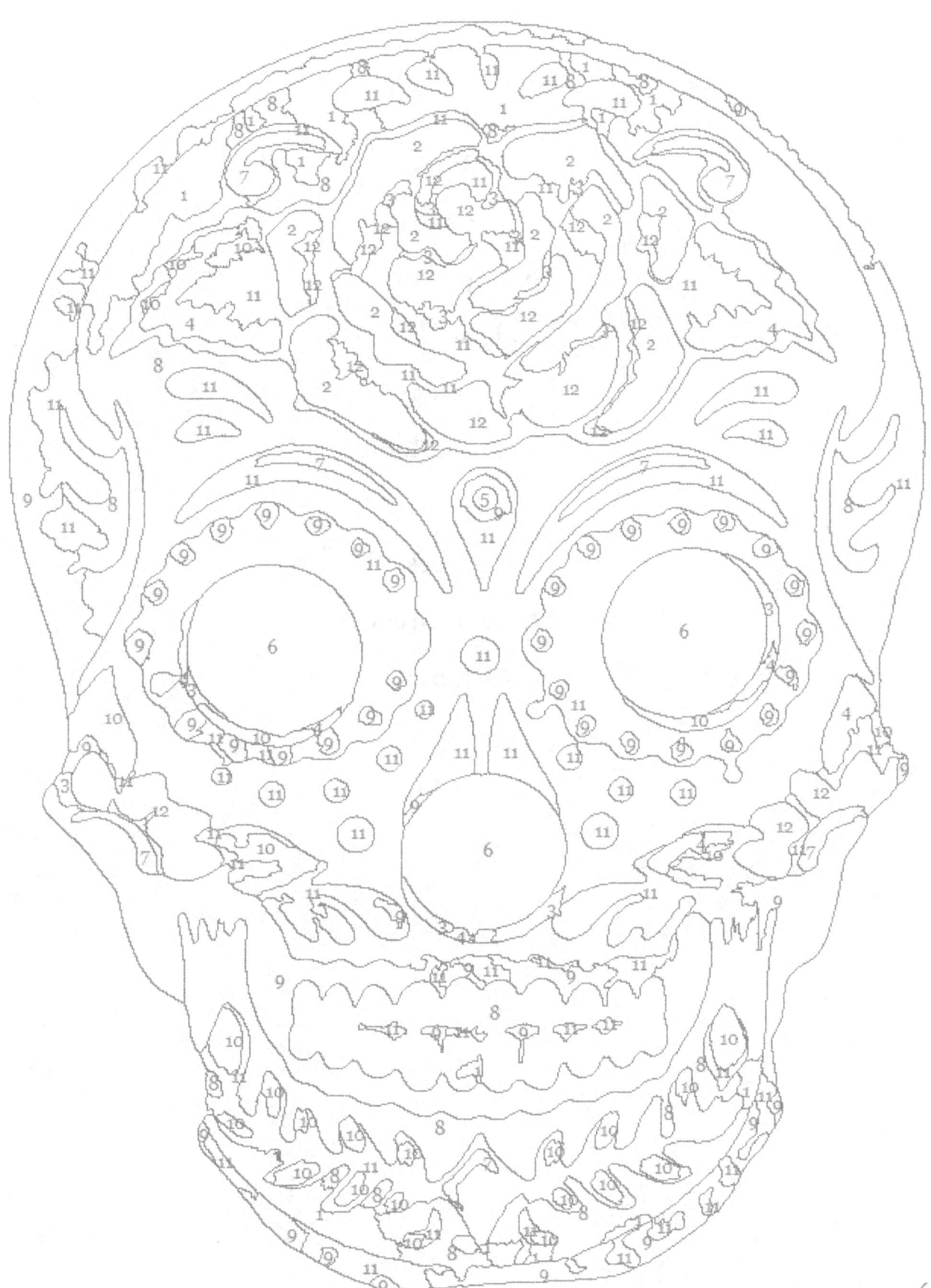

31. Red

32. Green

33. Blue

34. Pink

35. Purple

36. Light Blue

37. Light Green

38. Orange

39. Dark Red

40. Brown

41. Black

42. Dark Green

43. Gold

44. Violet

45. Yellow

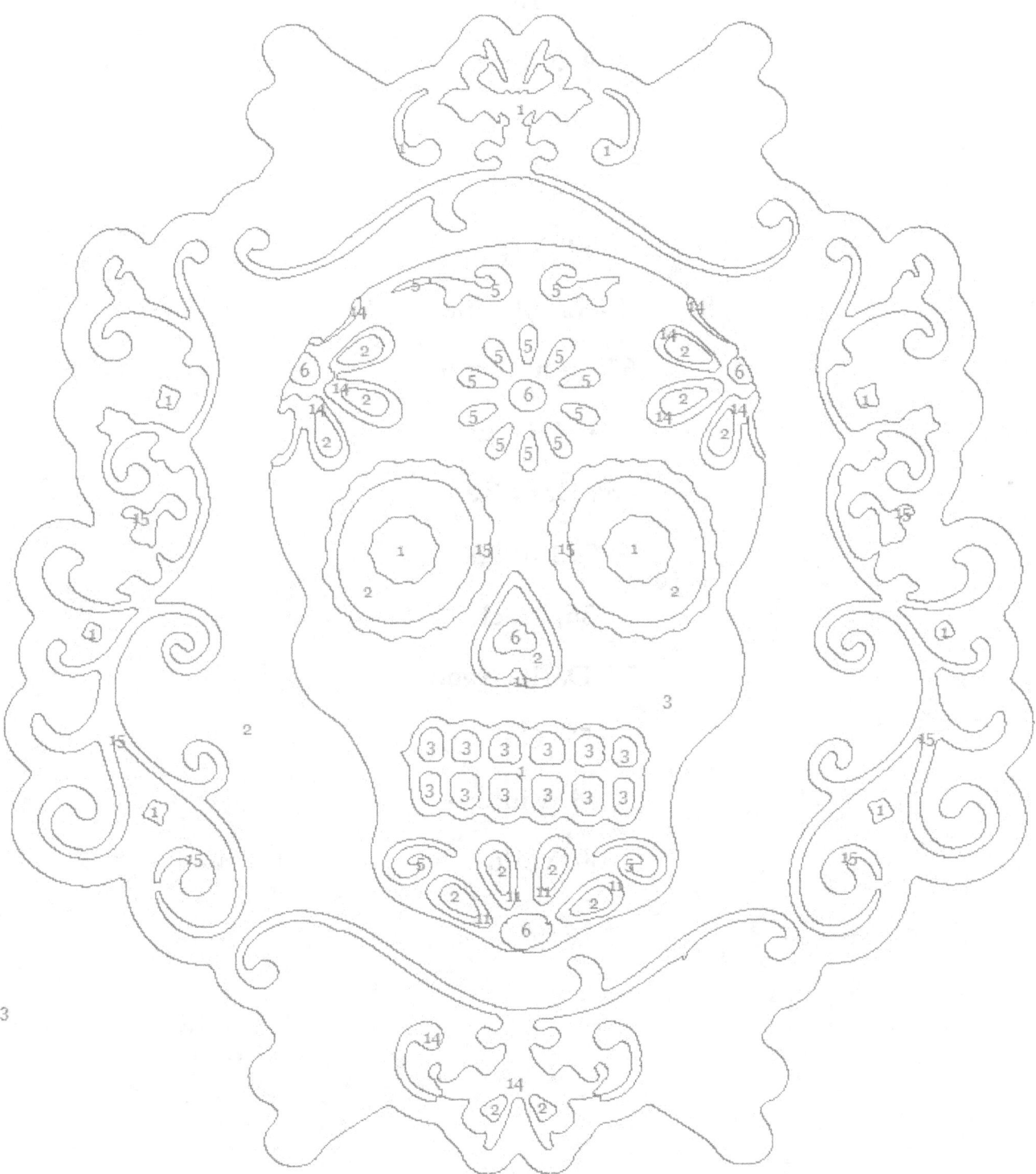

46. Red

47. Green

48. Blue

49. Pink

50. Purple

51. Light Blue

52. Light Green

53. Orange

54. Dark Red

55. Brown

56. Black

57. Dark Green

58. Gold

59. Violet

60. Yellow

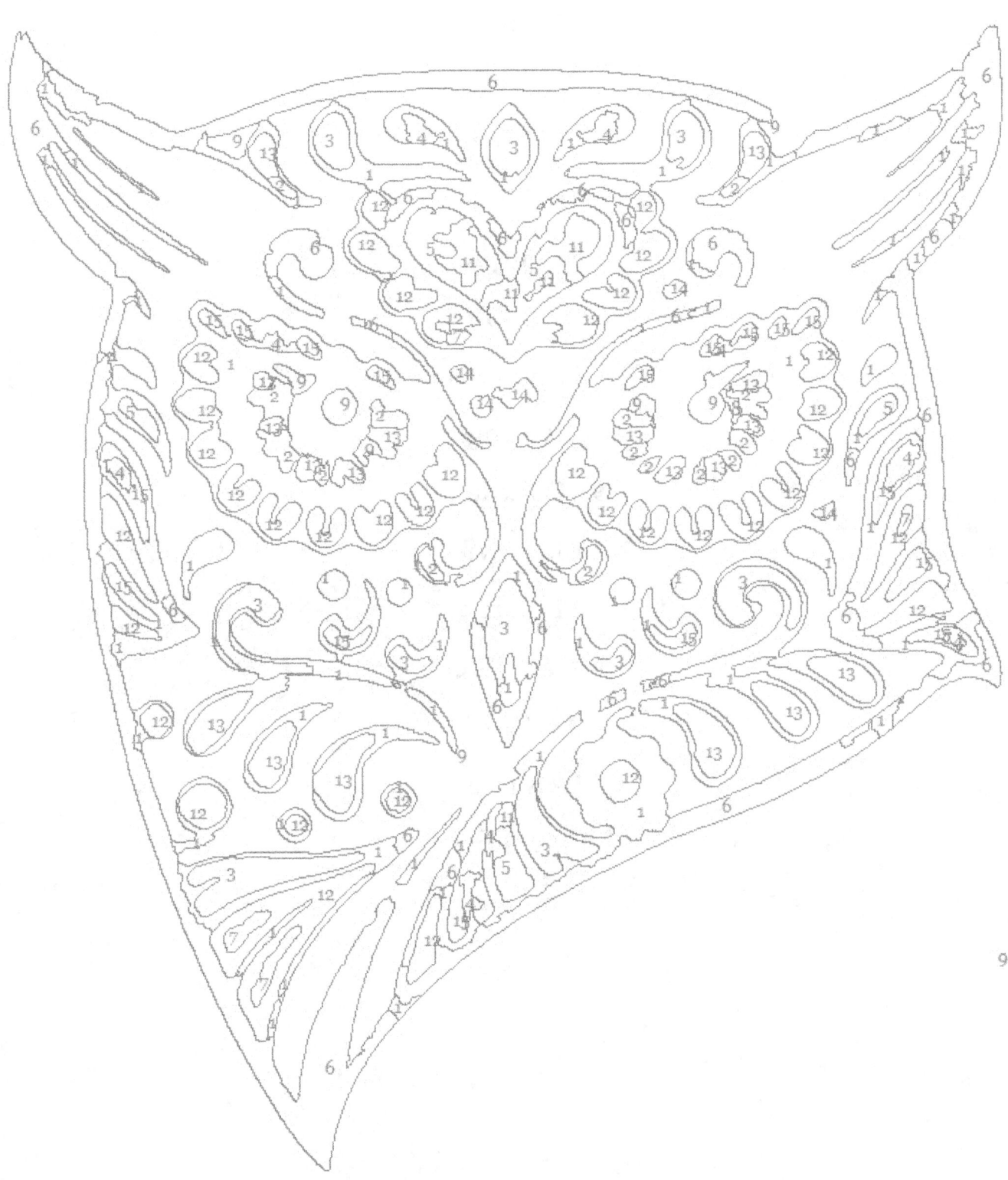

1. Red
2. Green
3. Blue
4. Pink
5. Purple
6. Light Blue
7. Light Green
8. Orange
9. Dark Red
10. Brown
11. Black
12. Dark Green
13. Gold
14. Violet
15. Yellow

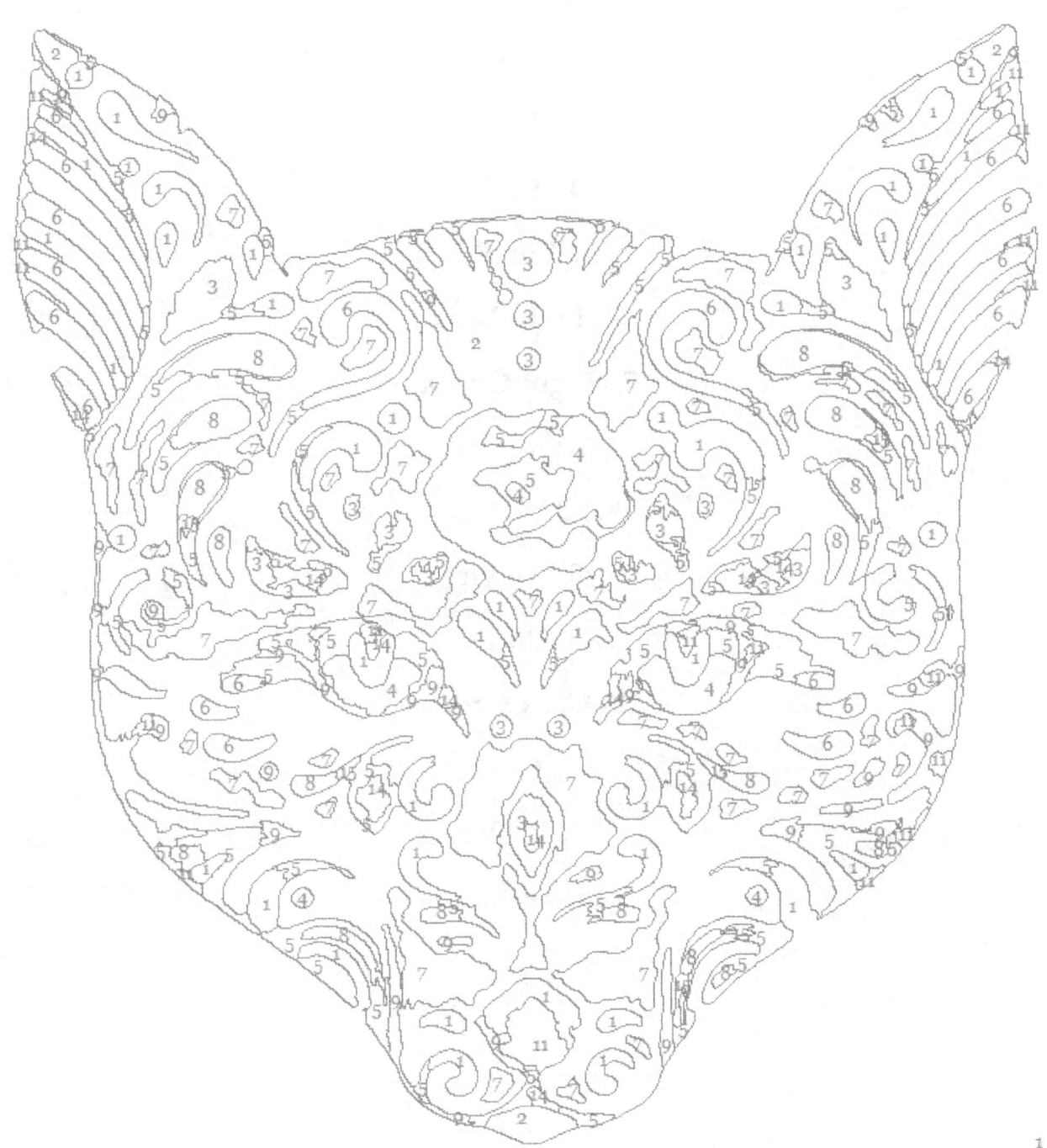

1. Red
2. Green
3. Blue
4. Pink
5. Purple
6. Light Blue
7. Light Green
8. Orange
9. Dark Red
10. Brown
11. Black
12. Dark Green
13. Gold
14. Violet
15. Yellow

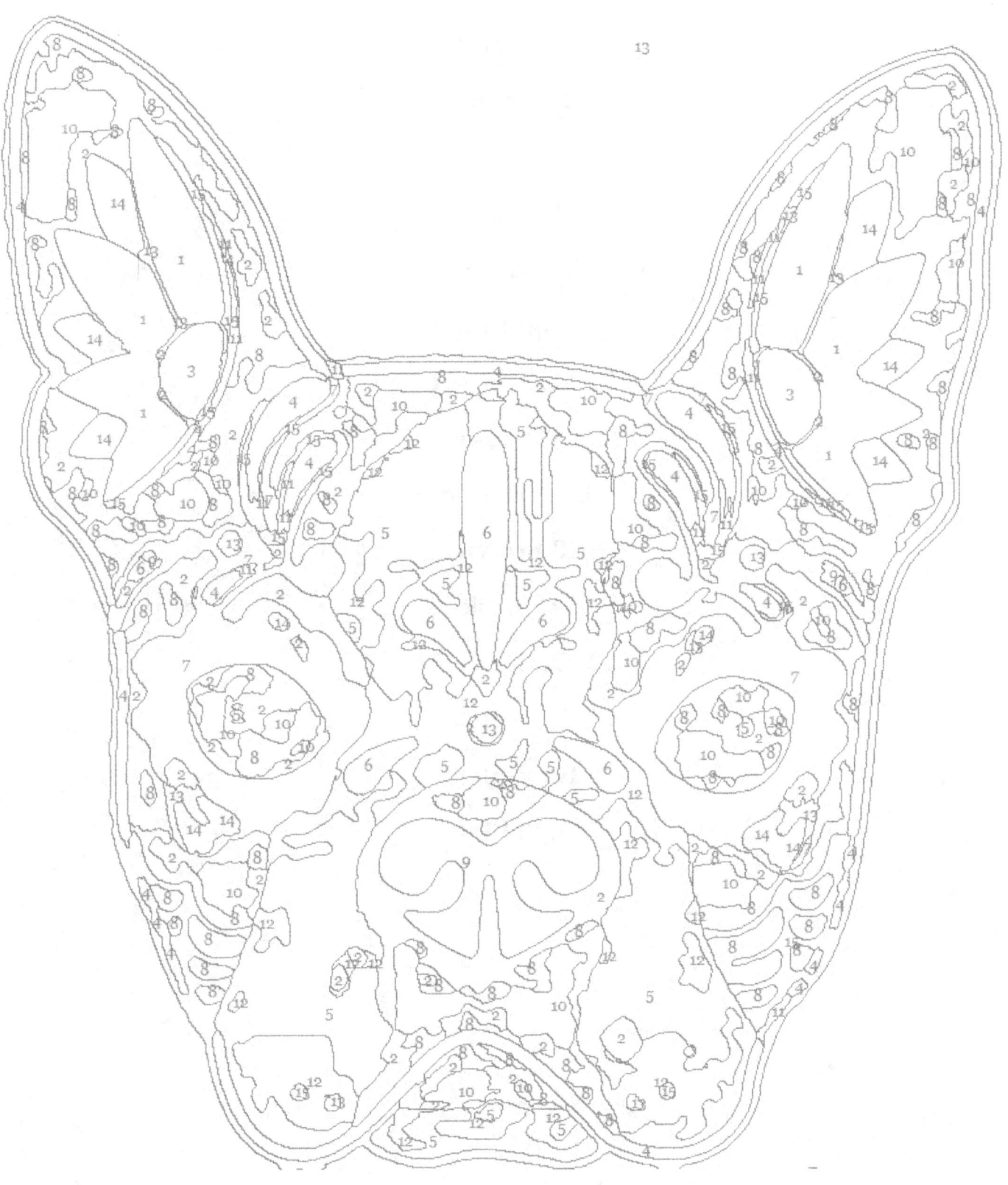

1. Red
2. Green
3. Blue
4. Pink
5. Purple
6. Light Blue
7. Light Green
8. Orange
9. Dark Red
10. Brown
11. Black
12. Dark Green
13. Gold
14. Violet
15. Yellow

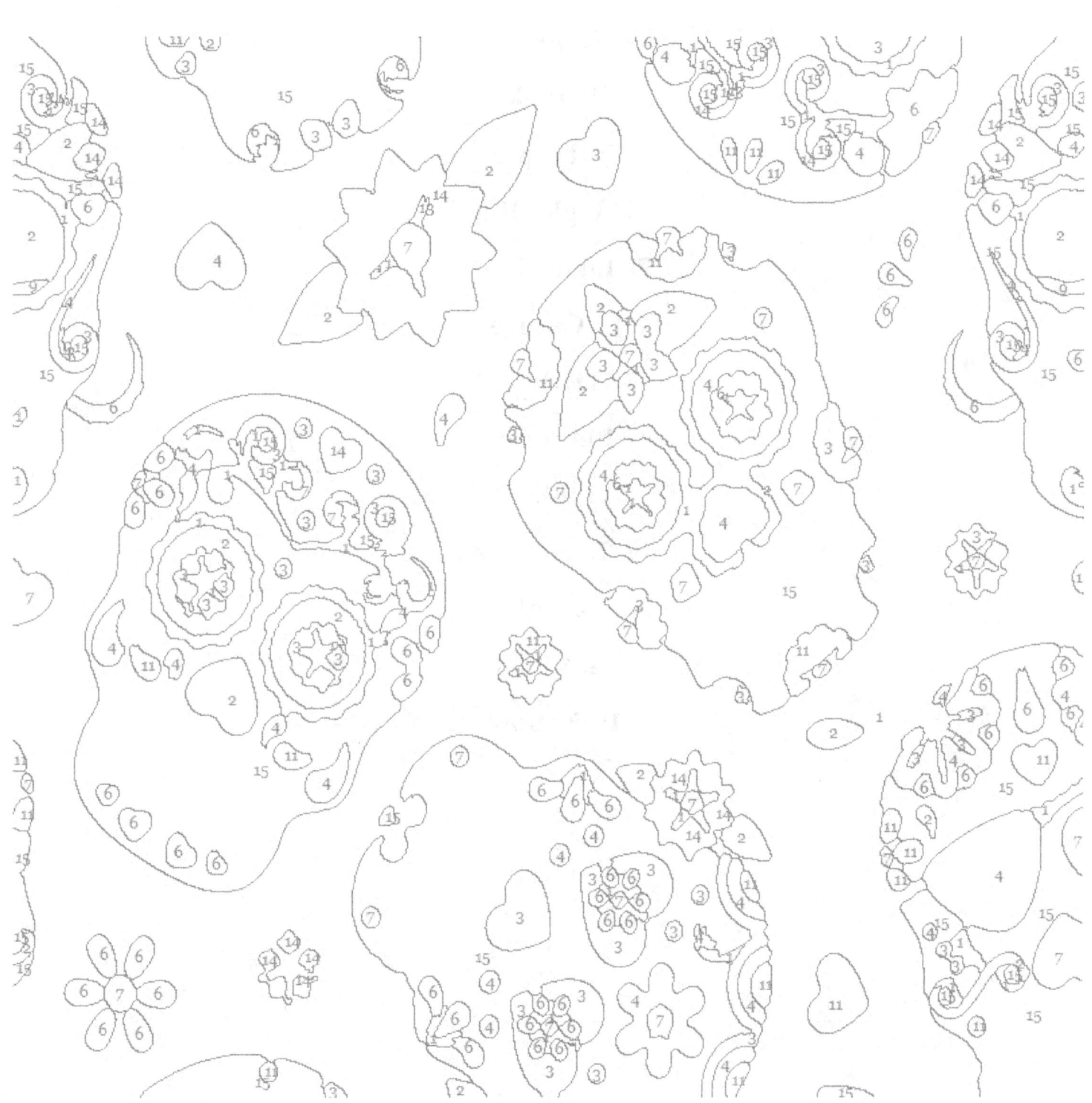

1. Red
2. Green
3. Blue
4. Pink
5. Purple
6. Light Blue
7. Light Green
8. Orange
9. Dark Red
10. Brown
11. Black
12. Dark Green
13. Gold
14. Violet
15. Yellow

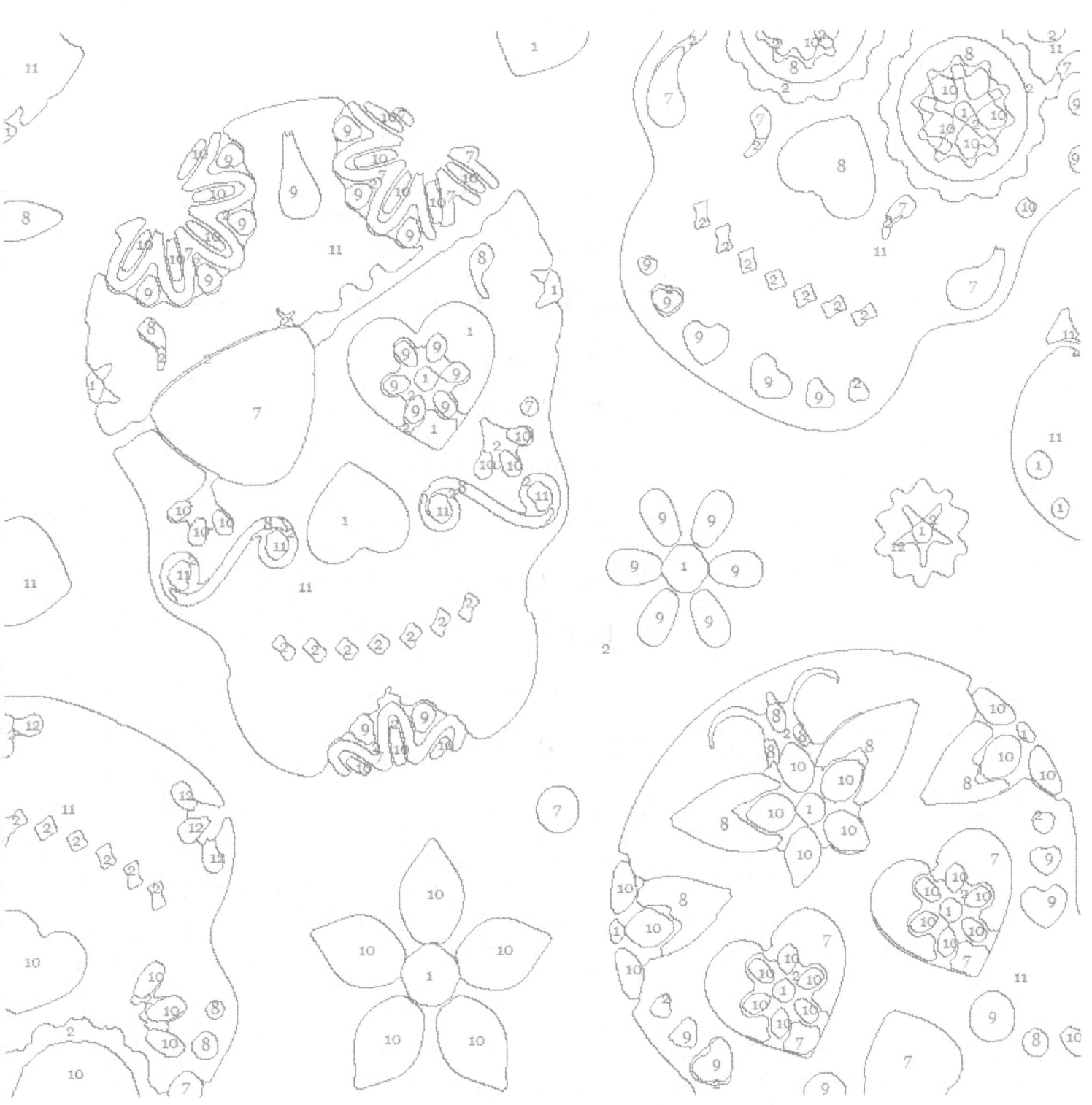

1. Red
2. Green
3. Blue
4. Pink
5. Purple
6. Light Blue
7. Light Green
8. Orange
9. Dark Red
10. Brown
11. Black
12. Dark Green
13. Gold
14. Violet
15. Yellow

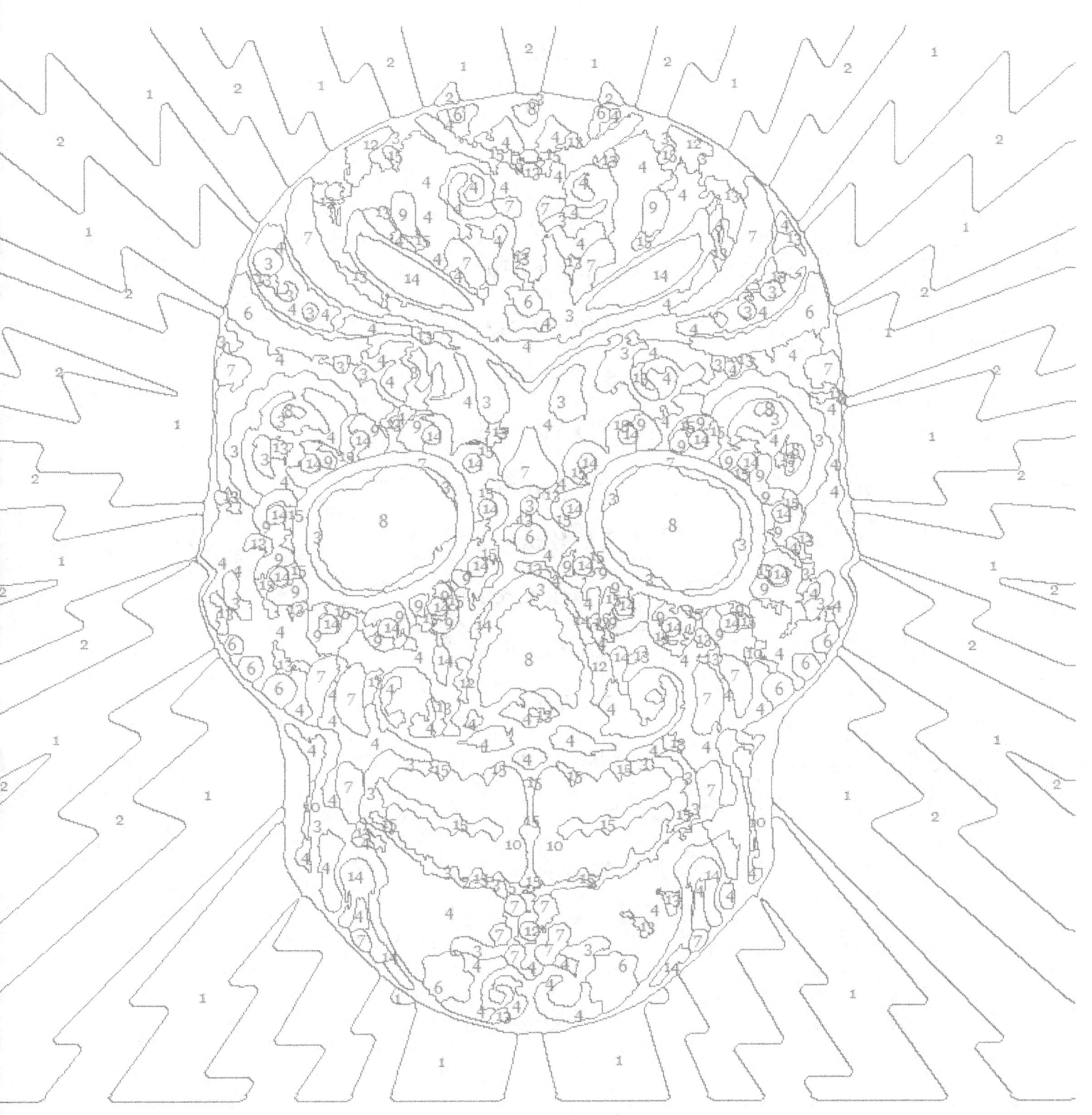

1. Red
2. Green
3. Blue
4. Pink
5. Purple
6. Light Blue
7. Light Green
8. Orange
9. Dark Red
10. Brown
11. Black
12. Dark Green
13. Gold
14. Violet
15. Yellow

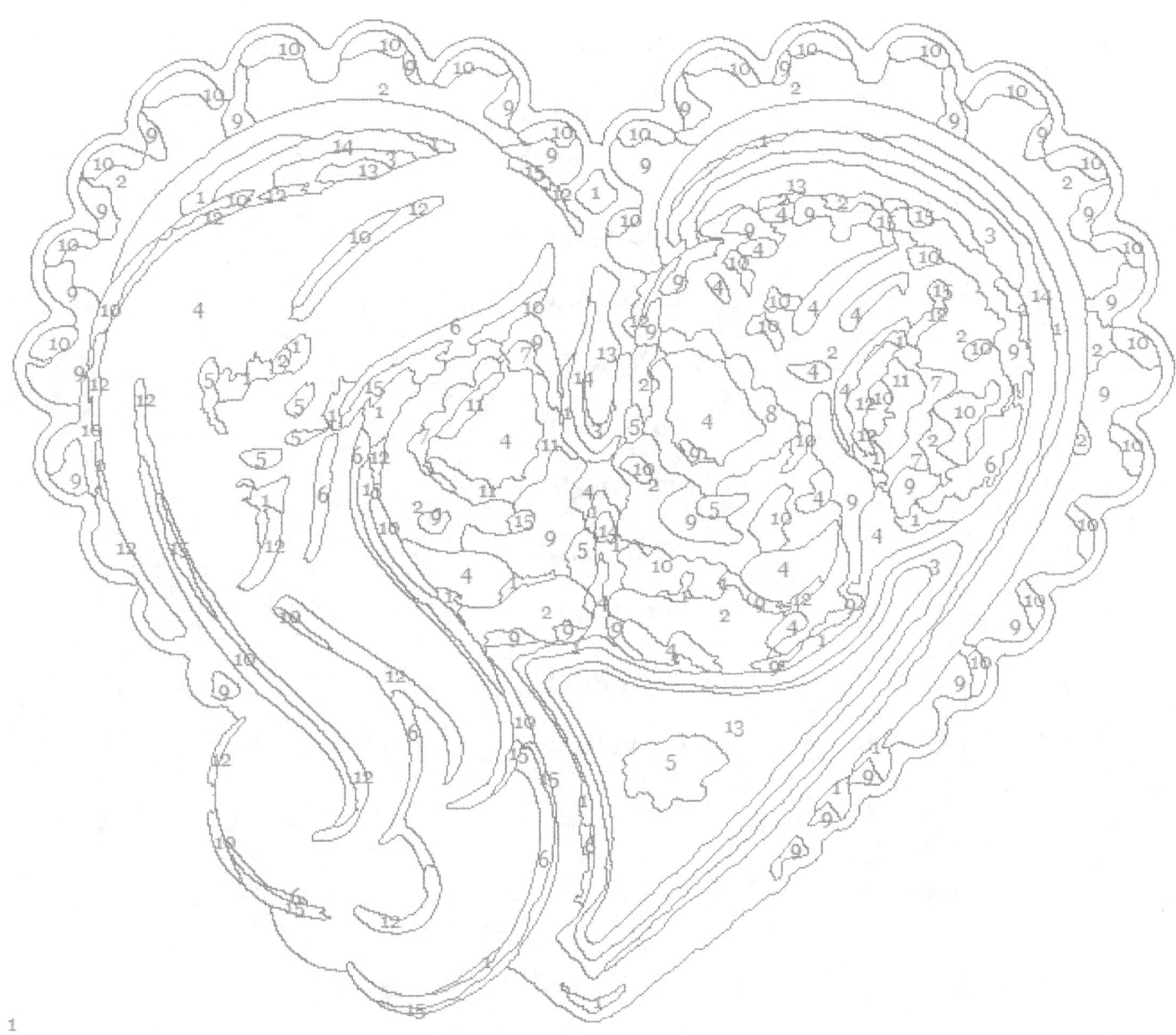

1. Red
2. Green
3. Blue
4. Pink
5. Purple
6. Light Blue
7. Light Green
8. Orange
9. Dark Red
10. Brown
11. Black
12. Dark Green
13. Gold
14. Violet
15. Yellow

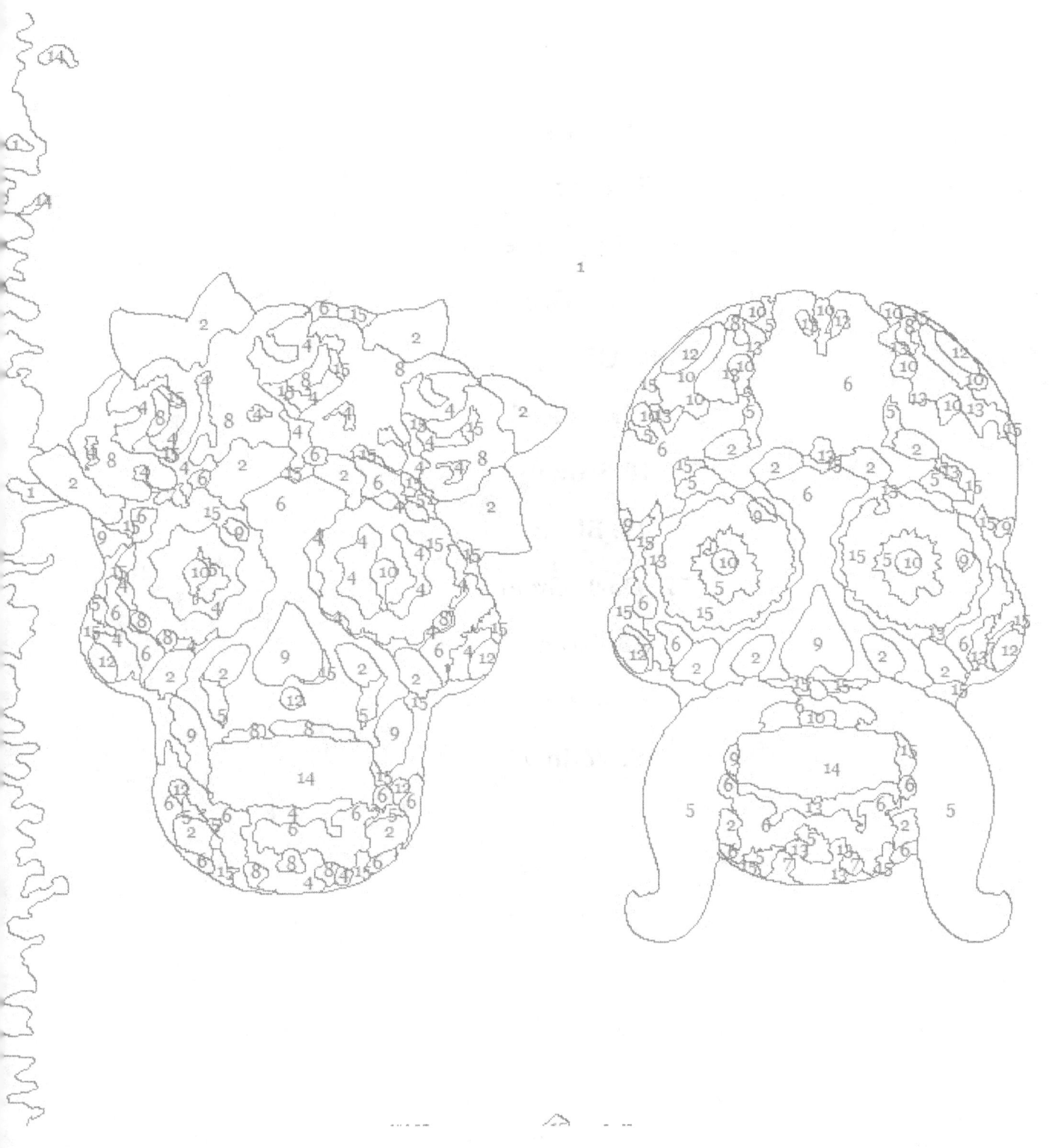

1. Red
2. Green
3. Blue
4. Pink
5. Purple
6. Light Blue
7. Light Green
8. Orange
9. Dark Red
10. Brown
11. Black
12. Dark Green
13. Gold
14. Violet
15. Yellow

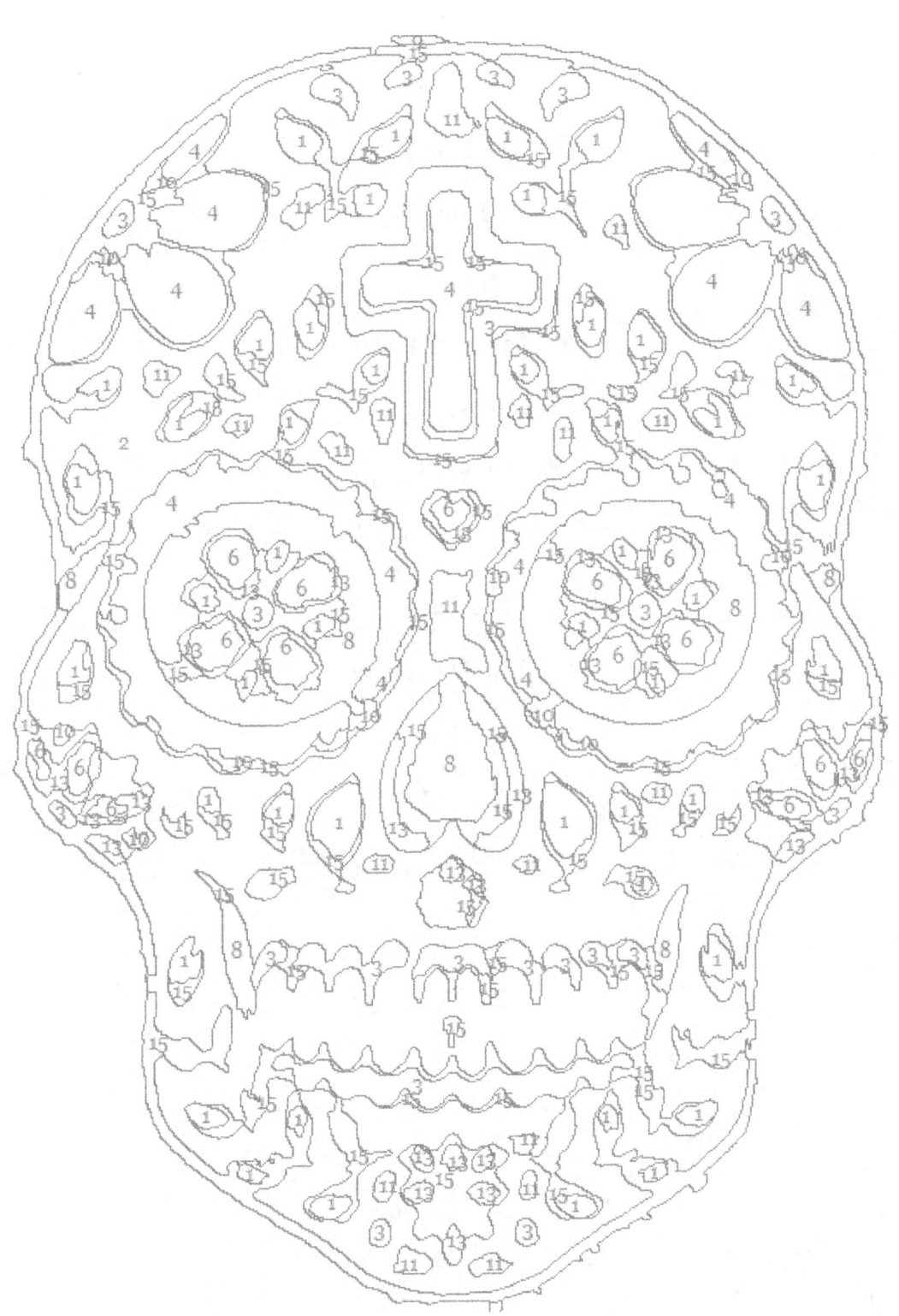

1. Red
2. Green
3. Blue
4. Pink
5. Purple
6. Light Blue
7. Light Green
8. Orange
9. Dark Red
10. Brown
11. Black
12. Dark Green
13. Gold
14. Violet
15. Yellow

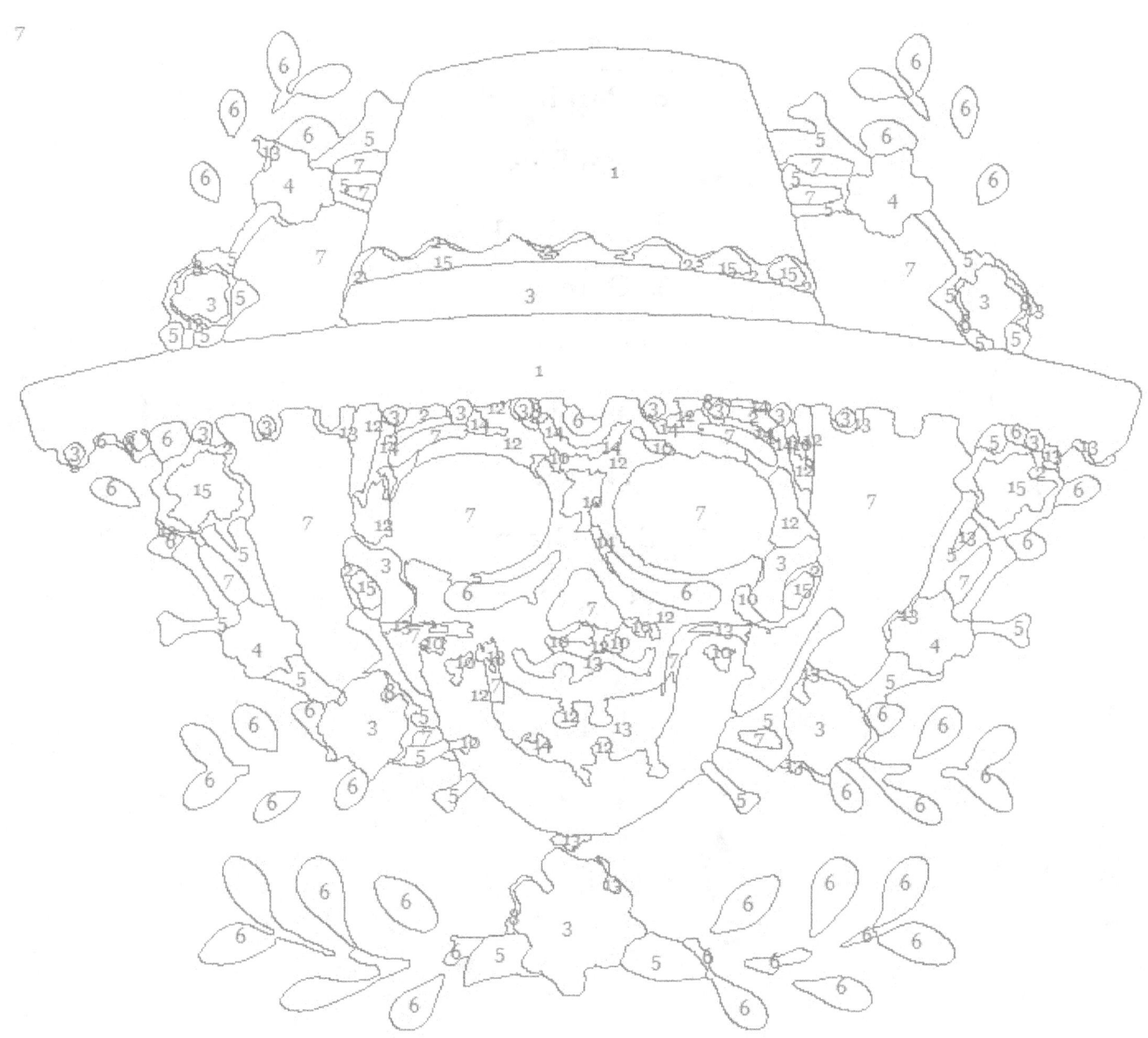

1. Red
2. Green
3. Blue
4. Pink
5. Purple
6. Light Blue
7. Light Green
8. Orange
9. Dark Red
10. Brown
11. Black
12. Dark Green
13. Gold
14. Violet
15. Yellow

1. Red
2. Green
3. Blue
4. Pink
5. Purple
6. Light Blue
7. Light Green
8. Orange
9. Dark Red
10. Brown
11. Black
12. Dark Green
13. Gold
14. Violet
15. Yellow

1. Red
2. Green
3. Blue
4. Pink
5. Purple
6. Light Blue
7. Light Green
8. Orange
9. Dark Red
10. Brown
11. Black
12. Dark Green
13. Gold
14. Violet
15. Yellow

1. Red
2. Green
3. Blue
4. Pink
5. Purple
6. Light Blue
7. Light Green
8. Orange
9. Dark Red
10. Brown
11. Black
12. Dark Green
13. Gold
14. Violet
15. Yellow

1. Red
2. Green
3. Blue
4. Pink
5. Purple
6. Light Blue
7. Light Green
8. Orange
9. Dark Red
10. Brown
11. Black
12. Dark Green
13. Gold
14. Violet
15. Yellow

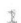

BONUS COOL SUGAR SKULLS COLORING PAGES

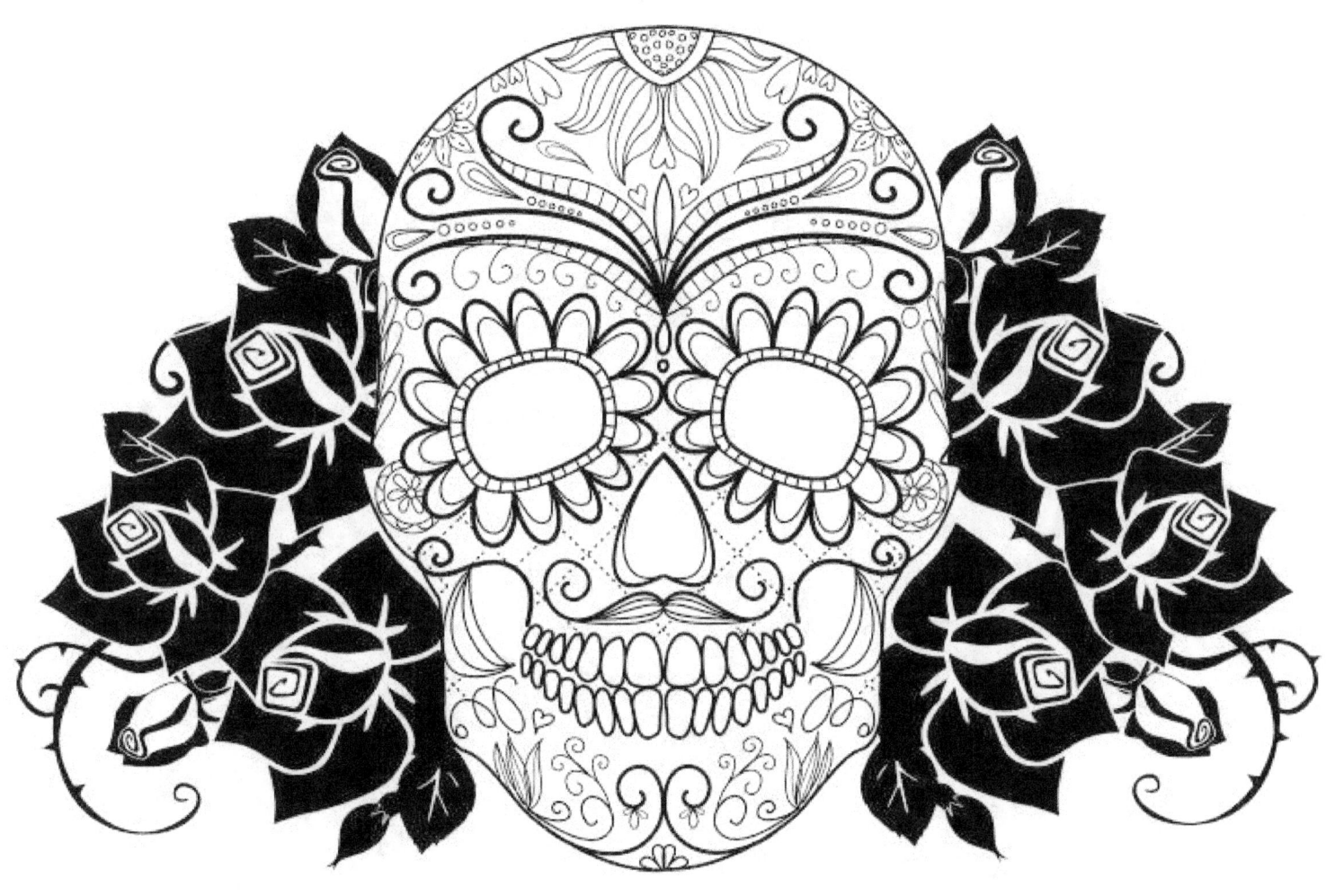

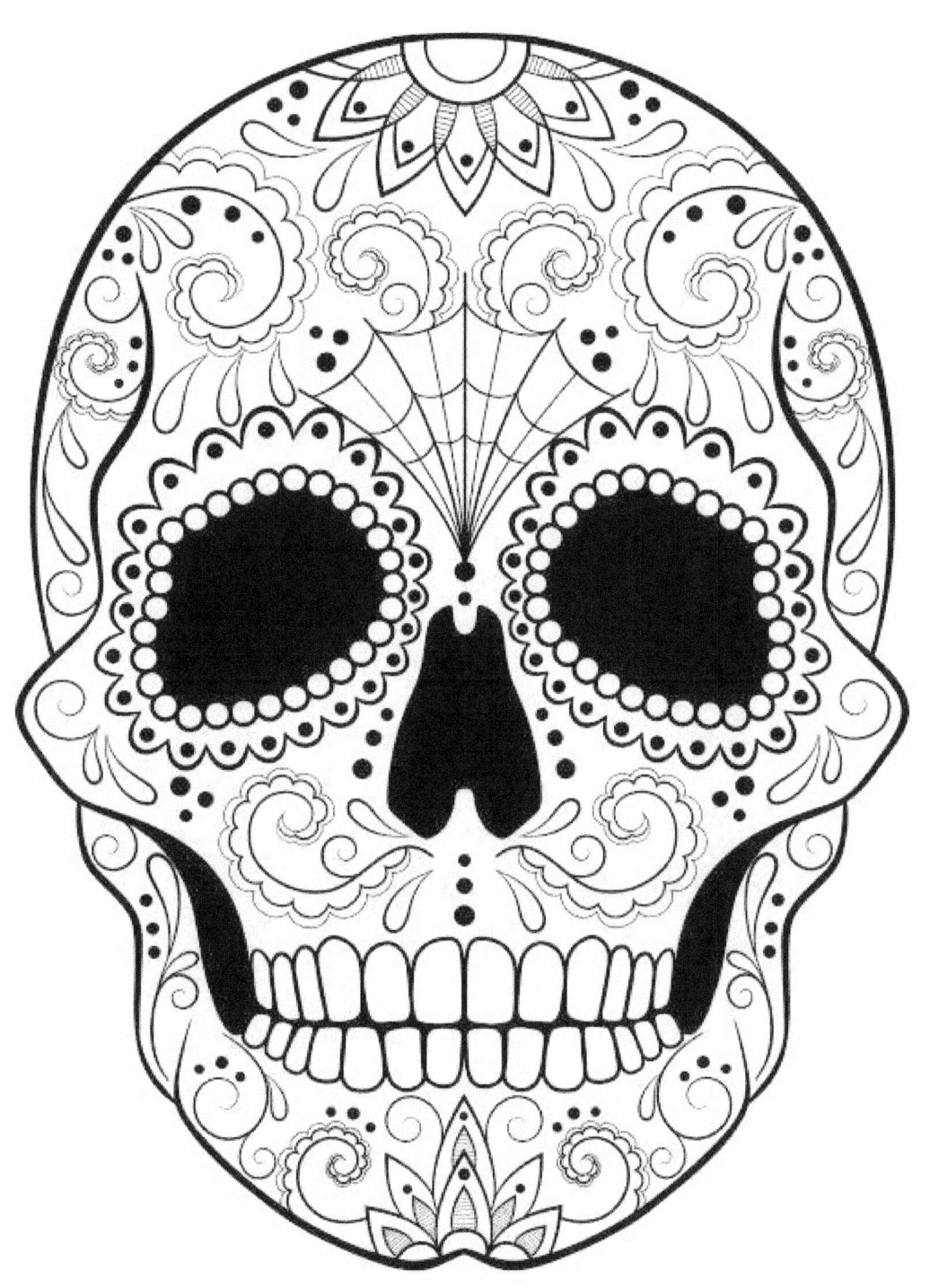

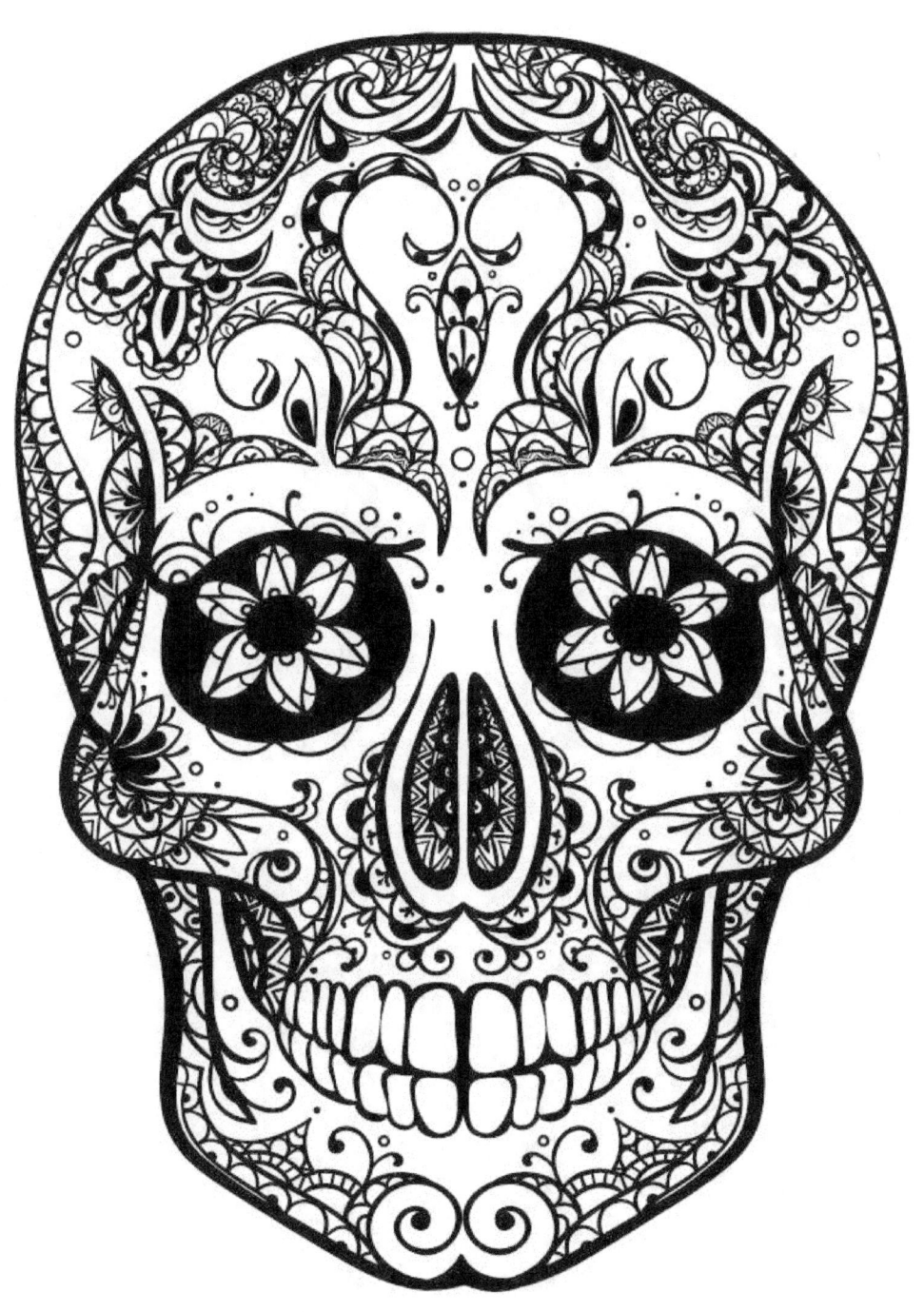

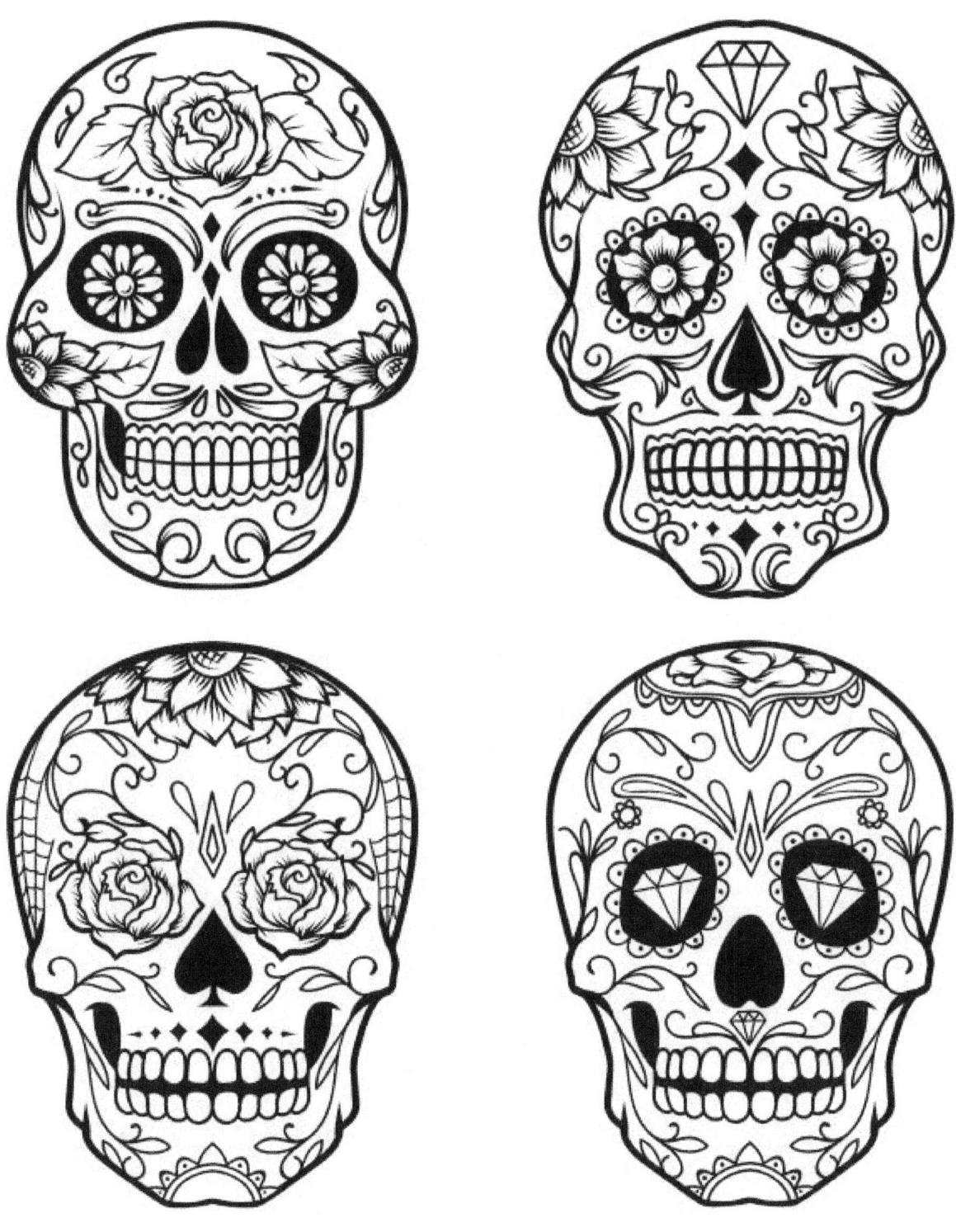

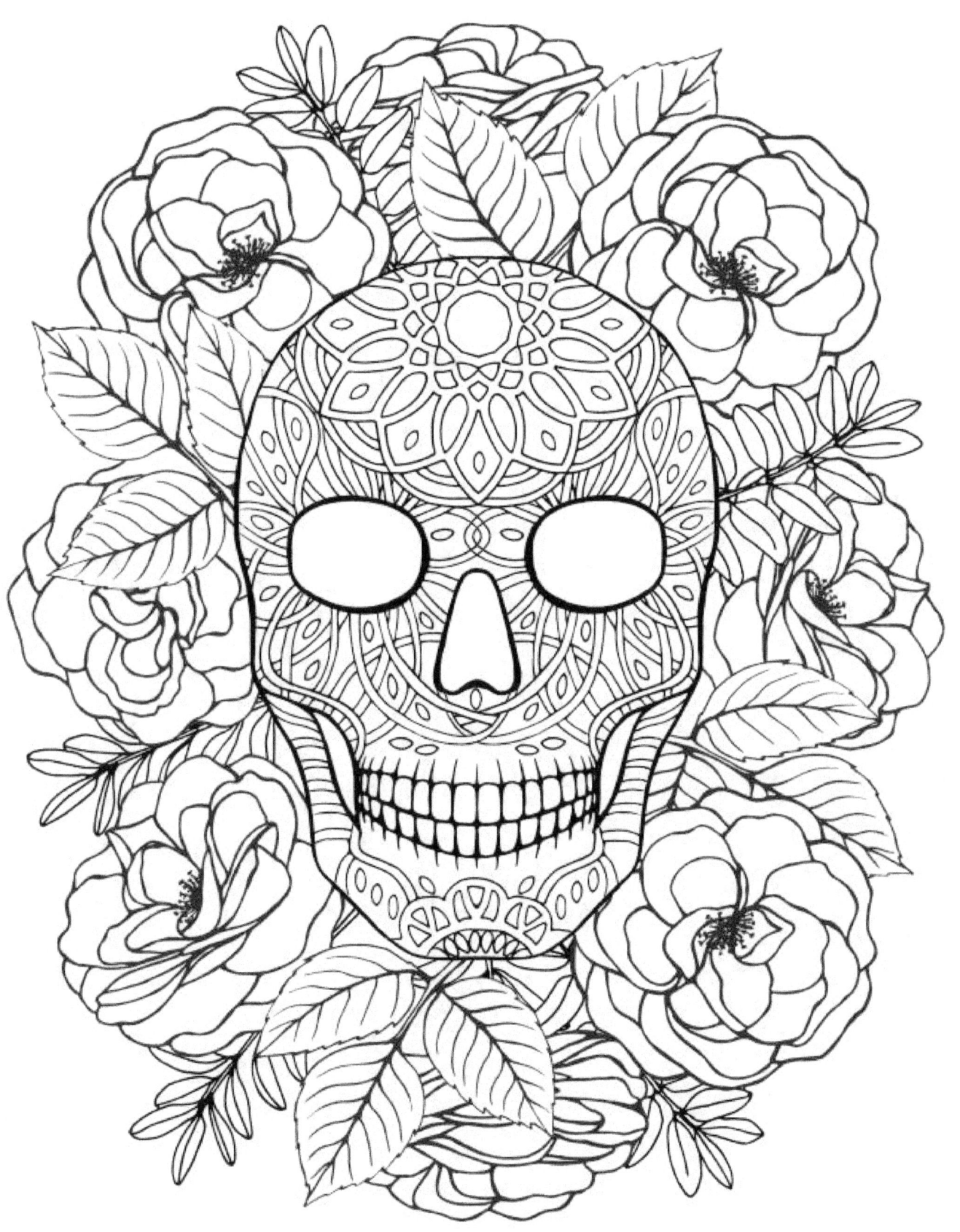

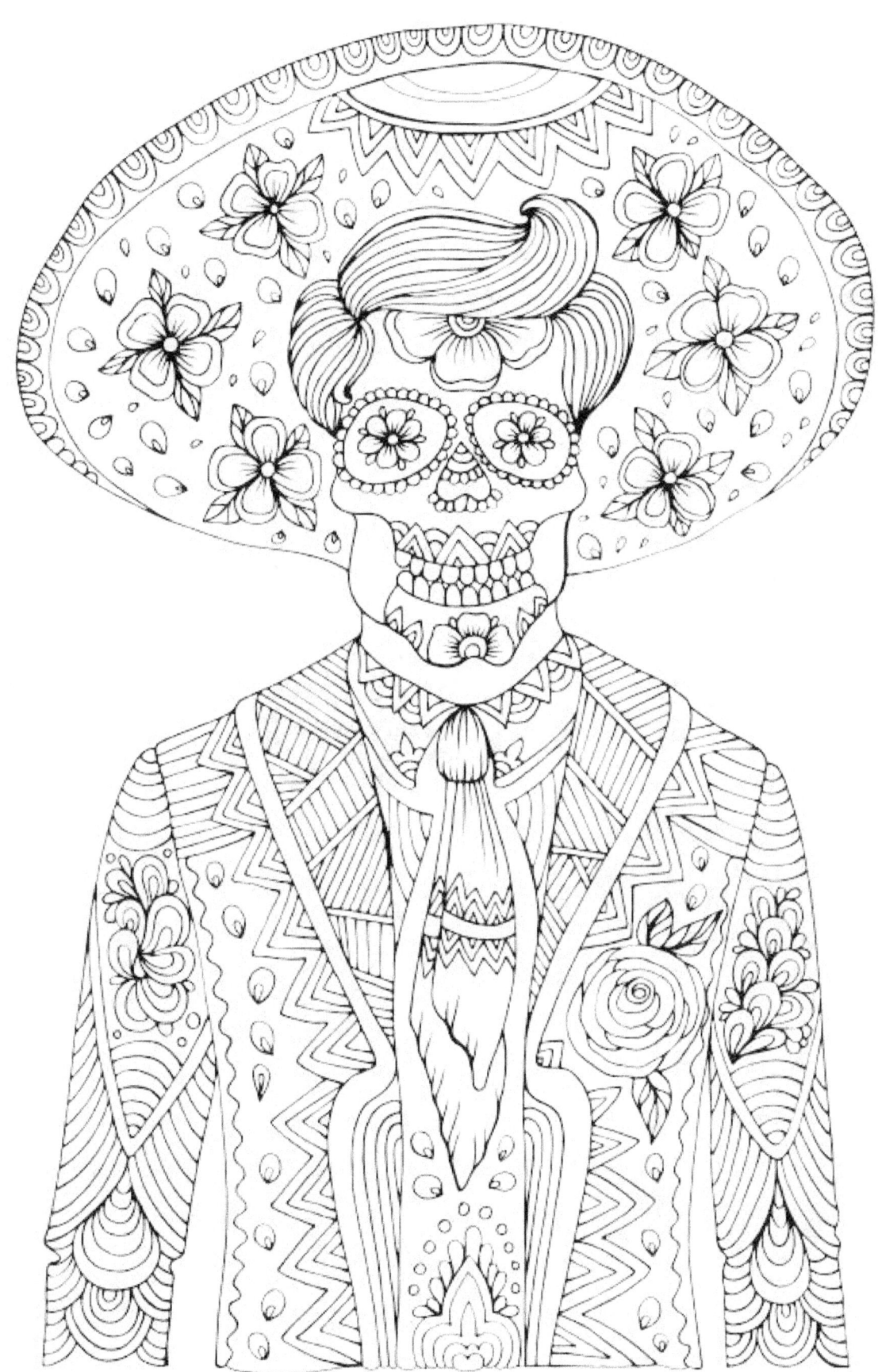

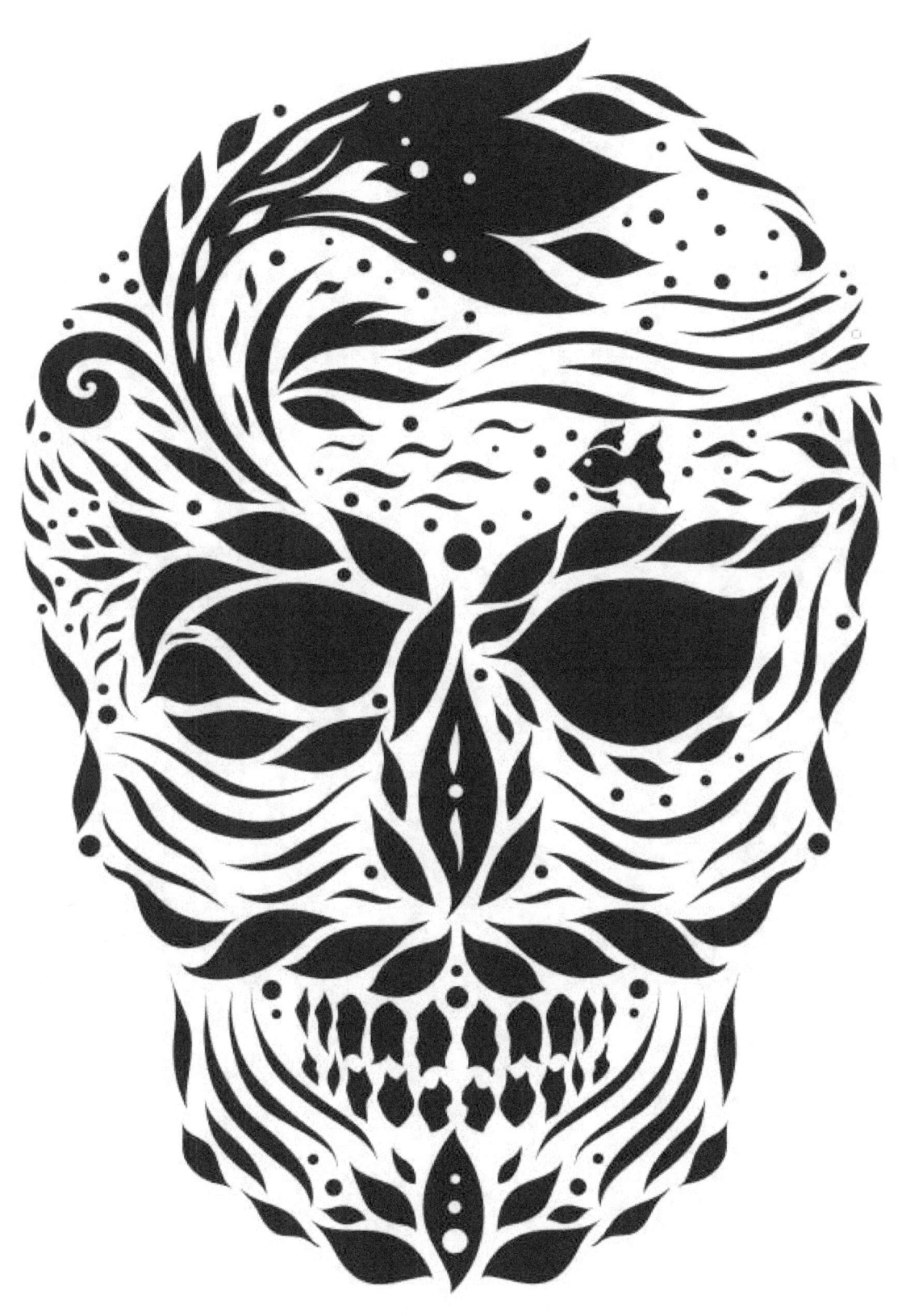

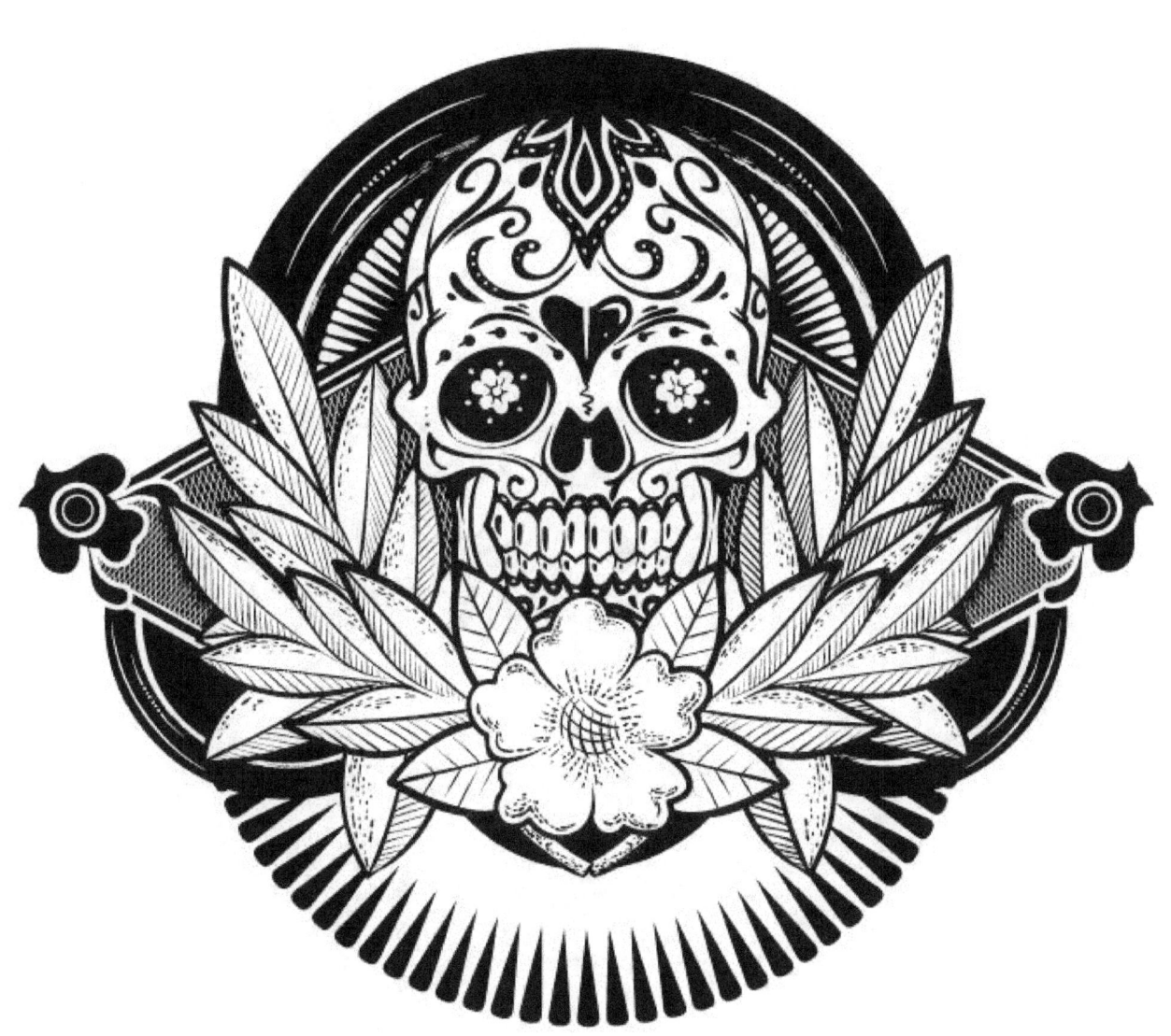

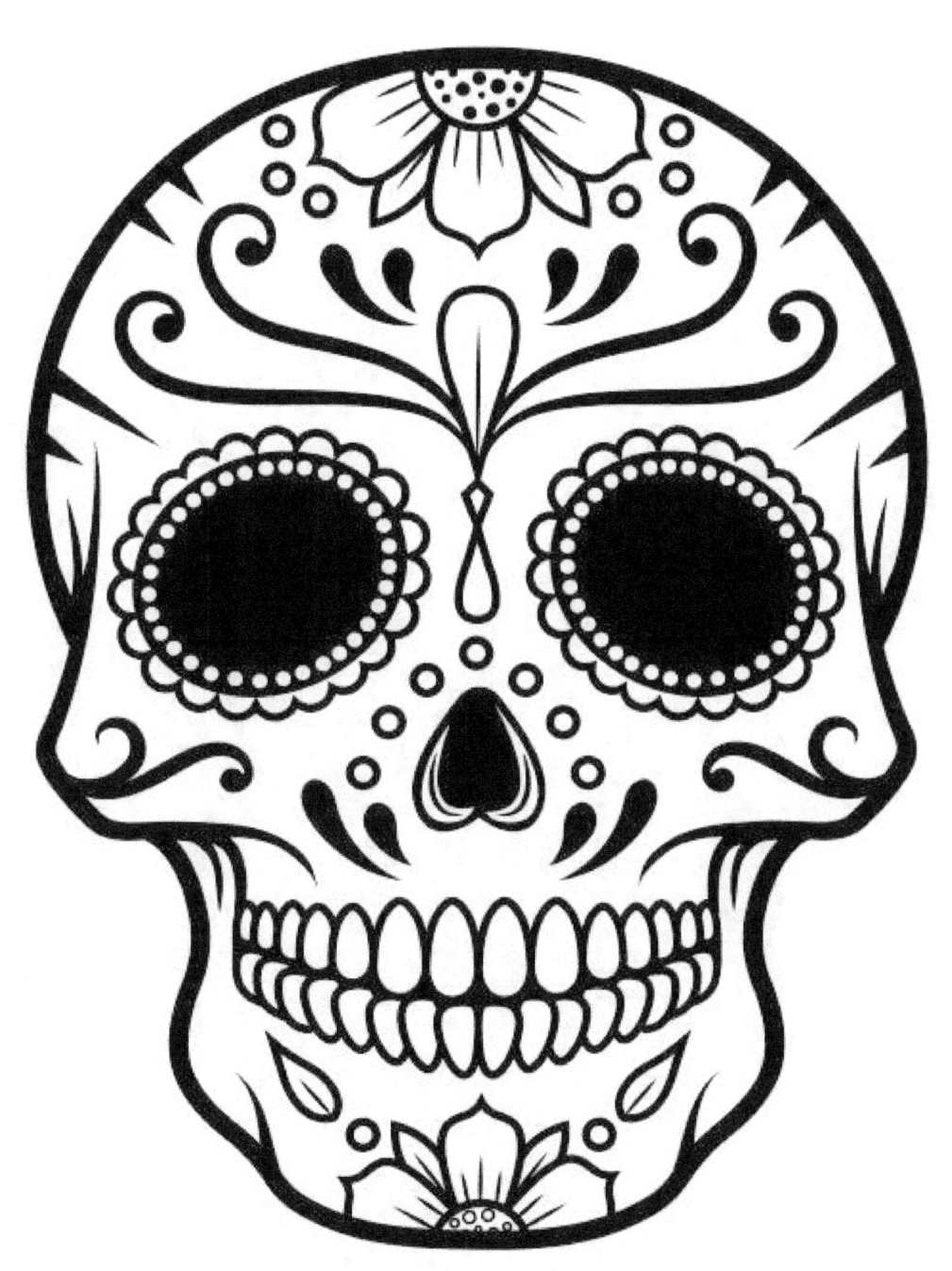

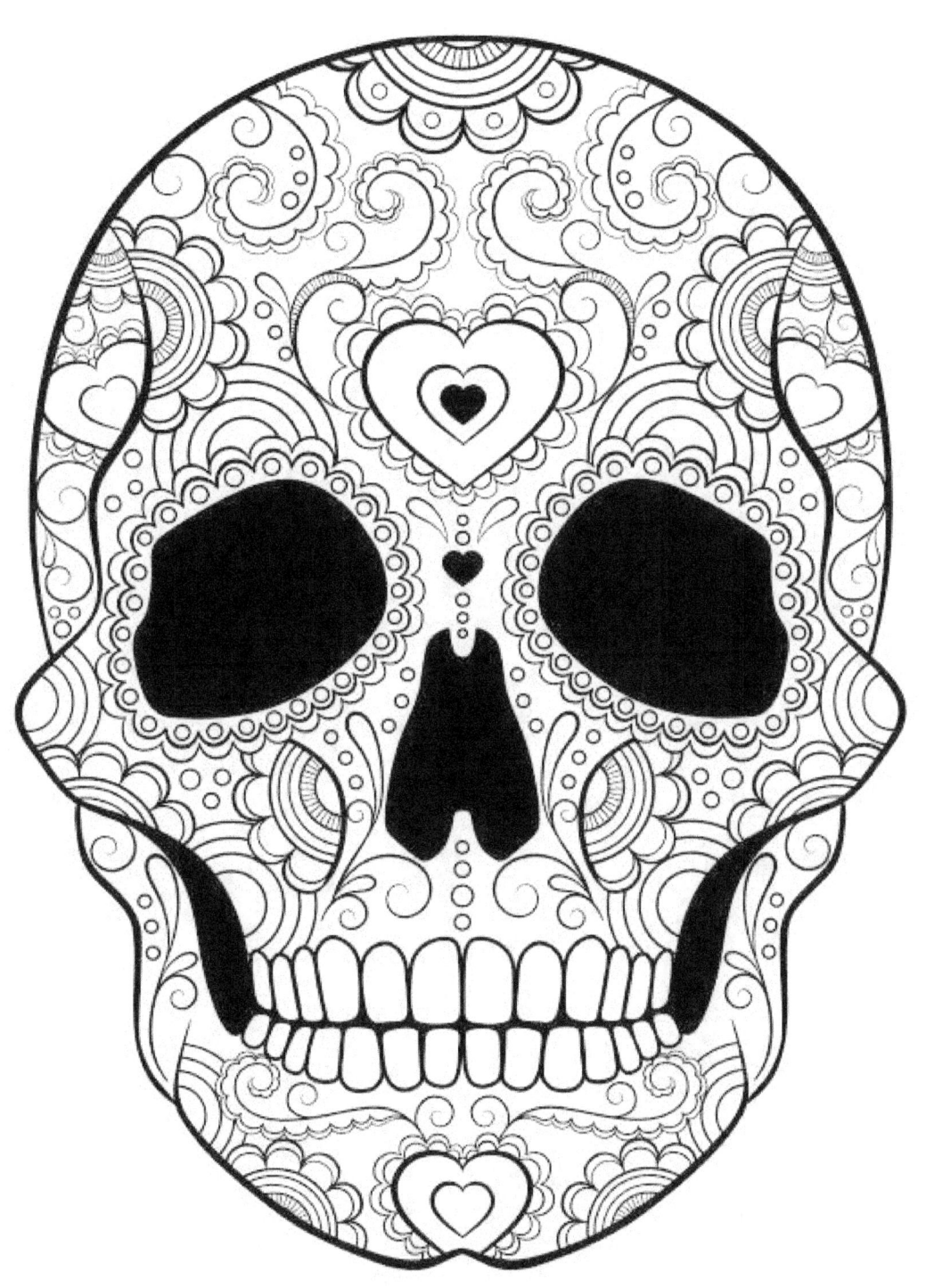

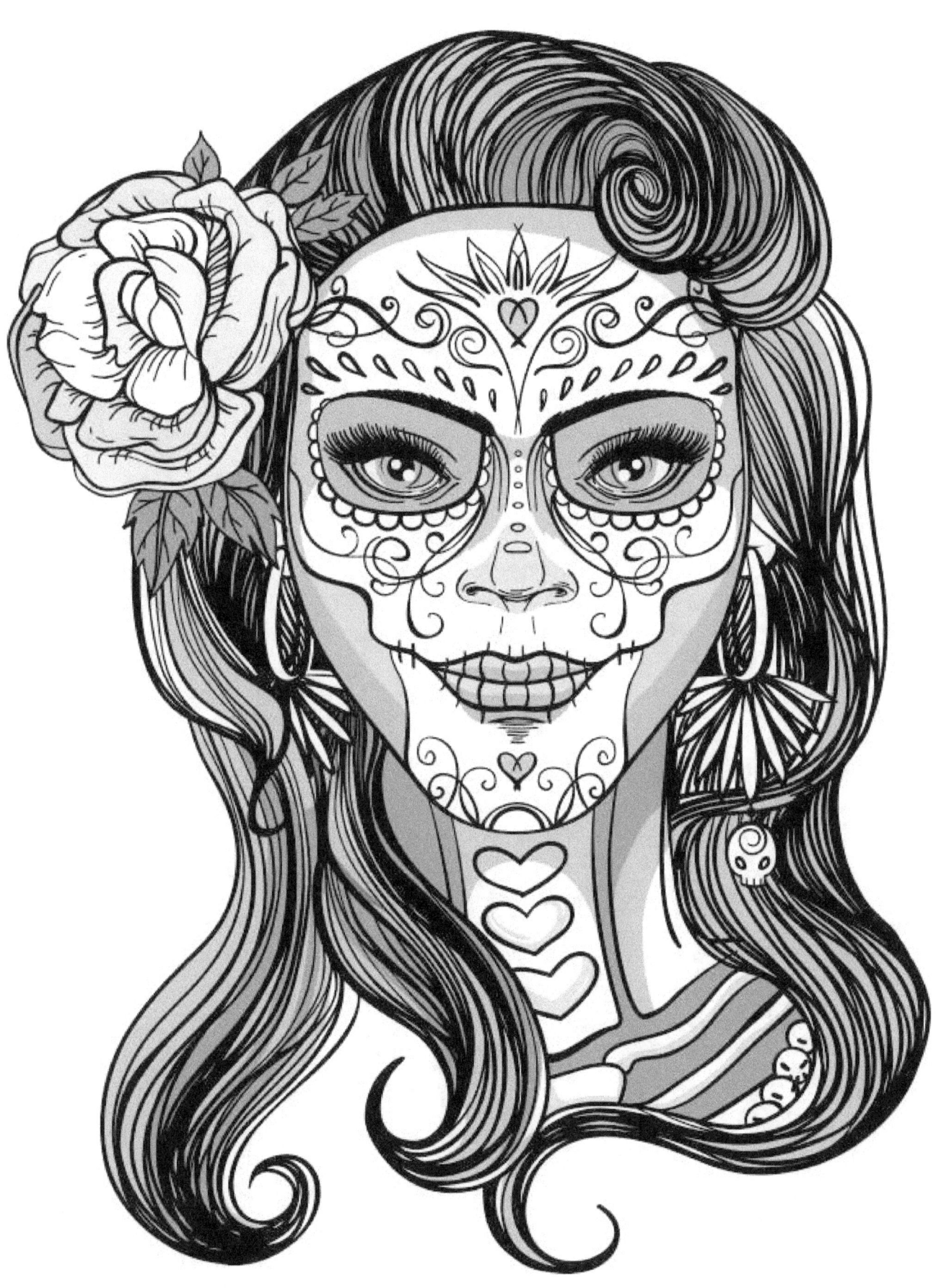

www.ingramcontent.com/pod-product-compliance
Lightning Source LLC
Chambersburg PA
CBHW081016170526
45158CB00010B/3066